EVERYDAY SKILLS
MADE EASY

DIGITAL ART
LIGHTING
BASICS

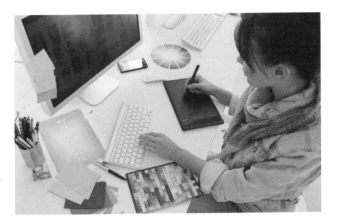

4721800005228 5

This is a **FLAME TREE** book
First published 2015

Publisher and Creative Director: Nick Wells
Project Editor: Catherine Taylor
Art Director: Mike Spender
Layout Design: Jane Ashley
Digital Design and Production: Chris Herbert
Copy Editor: Anna Groves
Screenshots and picture research: Rob Carney and Paul Tysall
Additional picture research: Josie Mitchell
Proofreader: Dawn Laker
Indexer: Eileen Cox

Special thanks to: Polly Prior and Taylor Steinberg

This edition first published 2015 by
FLAME TREE PUBLISHING
Crabtree Hall, Crabtree Lane
Fulham, London SW6 6TY
United Kingdom

www.flametreepublishing.com

© 2015 Flame Tree Publishing

15 17 19 18 16
1 3 5 7 9 10 8 6 4 2

ISBN 978-1-78361-393-9

Image Credits:
All original artwork in screenshots © Paul Tysall.

Additional product images and screenshots courtesy of and ©: 3Dconnexion; Apple; ArtRage © Ambient Design Ltd; Autodesk; AutoFX; Blender; Corel Corporation (Painter); Dell; Digital Film Tools; Epson; HP; MAXON Computer; Nikon; NVIDIA; Olympus; Red Giant Software; Samsung - All rights reserved; Savage Interactive; Wacom.

Other non-screenshot pictures: courtesy of Shutterstock.com and © the following contributors: wavebreakmedia 1, 8, 24, 78; vovan 10; Champiofoto 11; pongpinun traisrisilp 13; Pefkos 14; Kostenko Maxim 17; Pi-Lens 18; Sunny Forest 19; Kostenko Maxim 21; Webspark 23; zeljkodan 26; dnaveh 28; View Apart 29; sutulastock 30; Evgeniya Uvarova 34; scyther5 39; Eugenio Marongiu 40, 95, 98; racorn 42; dboystudio 43; Niyazz 44; Dikiiy 51; Sergey Nivens 52; Ollyy 66; Peerawit 69; Dragon Images 126; Cattallina 83; agsandrew 104; elwynn 90; Elena Kharichkina 93; Tithi Luadthong 96; Oleksiy Mark 106; Pablo Rogat 116; Sergey Nivens 5; Dasha Petrenko 102; JHK2303 114; shadow216 6; Paulo Resende 99; PeterPhoto123 65. © iStock.com and the following contributors: TayaCho 44; Szepy 48; courtneyk 49; konstantynov 101; paulrommer 88; SKrow 108; gecko753 111 (t); bedo 111 (b); PeopleImages 112; Nikada 120.

EVERYDAY GUIDES
MADE EASY

DIGITAL ART
LIGHTING
BASICS

ROB CARNEY & PAUL TYSALL
FOREWORD: AARON MILLER

FLAME TREE
PUBLISHING

CONTENTS

Discover what light is, the different kinds of light and how it behaves in the real world.

Apply realistic lighting in image creation: terms, concepts, and their practical application.

In this chapter, we explore the best digital painting and 3D applications, looking at their overall feature sets and the specific options for adding lighting effects.

This chapter focuses on invaluable step-by-step software techniques for lighting.

Here, we look at some of the most popular lighting plug-ins for Photoshop and compatible image-editing software and how they can be used to add effects to your work.

Essential kit for making great art – from Macs vs PCs, to graphics tablets and cameras.

FOREWORD

All objects in nature affect each other's lighting in one way or another, whether it's casting a shadow, or reflecting light, back lighting or side lighting onto a surface. Think of a warm sunset: the light that floods the landscape, warm oranges and pinks. Now compare that to a dark, winter's evening. With the use of this guide, you will learn all about how objects are affected by their surroundings and how we perceive light in the real world.

One of the most crucial aspects of ensuring that digital paintings look authentic and realistic is to have the direction of light consistent across all the elements in the image. Taking into account the direction of the light source when creating shadows, colour, contrasts and light bouncing off reflective surfaces helps to create atmospheric compositions with a real sense of depth.

Applying the techniques described in this book will enable you to create professional, believable and realistic digital works, even if you are creating work based on your imagination, or fantasy scenes. You will be talked through step-by-steps, including how to apply colour and lighting corrections on a piece of artwork, which is really useful for tying all colours in together to help unify the piece. These rules are transferable, and in time, will help you develop a new skill set, the confident ability to apply a light source consistently and effectively when painting. Think of the great masters, the famous paintings you see in galleries – what makes them so dramatic, emotive and atmospheric? The lighting the artist has depicted. The beauty of working digitally, of course, is that we can learn from our mistakes and we have the ability to undo our last brush stroke.

Aaron Miller, Artist, graphic designer and illustrator

INTRODUCTION

Lighting is such a fundamental yet complicated aspect of art – whether you want to paint using digital techniques or traditional methods. This book is here to simplify the topic for you and start you off on the right foot, so you can create fantastic digital art.

UNDERSTAND THE THEORY

Throughout Digital Lighting Basics, which is split into six chapters, we bring you some key lighting theory – including the basics of reflection, refraction, diffraction and more – as well as how to apply this to your own digital paintings.

Hot Tips

Look out for the Hot Tips, which give invaluable snippets of wisdom, shortcut advice and quick tips.

START PAINTING!

Moving through the book, we bring you an introduction to the incredible 2D and 3D software available for digital artists, then, with the help of digital artist Paul Tysall, we show you how to use the most popular – Photoshop – to create fantastic digital lighting effects. There are also chapters on popular plug-ins such as Knoll Light Factory and Auto FX's Mystical Lighting and how to kit out your studio with the best Mac or PC, graphics tablet, monitor and other peripherals for digital painting.

SMALL CHUNKS

What's different about this book compared to other technical guides? Well, we bring you everything in easy-to-digest, bite-size chunks, meaning you can dip in and out of the book as you please – and learn something new and exciting every time you do so.

STEP-BY-STEP GUIDES

Everything is aimed at the beginner: where there's jargon, we've explained it either in easy-to-understand blocks of text or with a useful diagram; where there are complicated techniques, we've simplified them in a step-by-step, easy-to-follow format. So read on for everything you need to know to get started with lighting techniques in digital painting.

ALL ABOUT LIGHT

THE IMPORTANCE OF LIGHT

Whilst we see light as colour and brightness, light is radiant energy – electromagnetic radiation that makes things visible. In art and photography, light is the most important ingredient. Light and its relationship with colour, defines our work, giving it form and feeling. Mastering the phenomenon of light, both natural and artificial, interacting with matter is a huge part of becoming a great artist. Once you can create convincing, realistic lighting, you can begin to create fantastical scenes and visions.

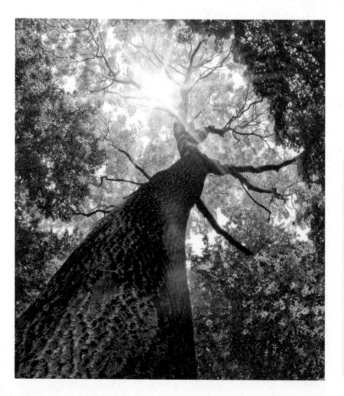

TYPES OF LIGHT

There are two kinds of light that you'll need to know about to successfully define your digital – or indeed traditional – artworks: natural and artificial.

Hot Tip

Direct light usually has cooler colours, with warmer colours in shadow, whereas artificial light has much harsher qualities than natural light, creating strong shadows and warmer colours in direct light, with cooler colours in the shadows.

Natural Light

Natural light is all around us. Radiation from the sun is filtered through our atmosphere, then either diffused by clouds or transmitted as direct sunlight. Whereas bright sunlight can be harsh in its qualities, natural light – in artistic terms – is usually characterized by the subtle, soft shadows it creates and the cool, peaceful, calm mood it invokes.

Artificial Light

Artificial light is man-made, light that is powered by electricity or another energy source, such as light bulbs, fluorescent lighting and even candles (as the light source is coming from a man-made object).

HOW LIGHT BEHAVES

Light travels in straight lines, and these light rays (it's useful to think of light as rays or waves, as then it's easy to visualize the phenomena that follow) can be 'controlled' by either blocking or manipulating them. Let's look at the phenomena of reflection, refraction, diffraction and interference.

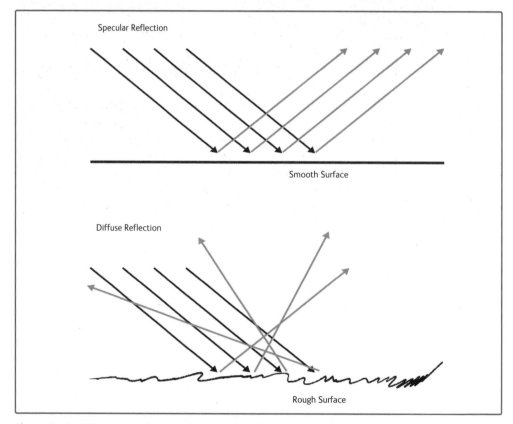

Above: When light hits a smooth surface, it is reflected. This image shows how specular and diffuse reflection differ.

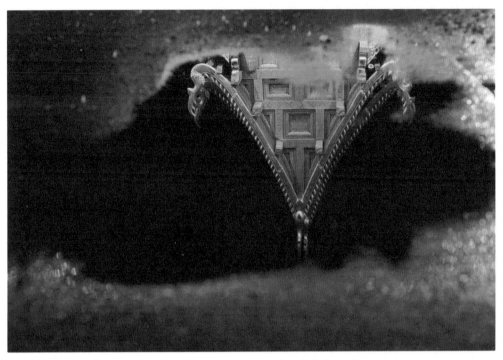

Above: Specular reflection happens when light reflects back at the same angle at which it hit an object, creating a mirror image, such as in this puddle.

REFLECTION

When light hits a smooth surface, reflection occurs. There are generally two types of reflection – specular and diffuse, but many surfaces exhibit both specular and diffuse reflection. It's important to understand the distinction, as it will affect how you paint or render different materials in your artwork.

Specular Reflection

When explaining specular reflection, it's useful to take a mirror as an example. When the light hits the mirror, it reflects at an angle equal to the angle at which it hit the surface. This is known as specular reflection.

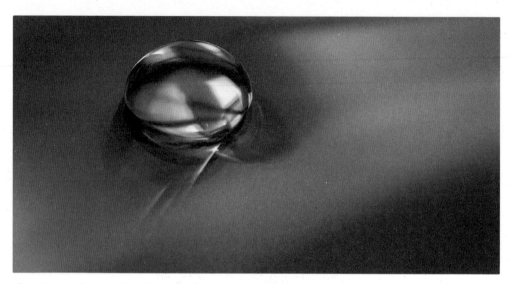

Above: Even a small water droplet will make light refract.

Diffuse Reflection

Of course, not all surfaces are smooth. When light hits a rougher surface – think of a painted wall, for instance – light is reflected at many different angles, diffusing it and therefore creating a surface with little or no glare. It might also help to think of a road surface: when dry, it's rough and diffuses the light; when wet, the water disguises the roughness and the light reflects off the surface, creating glare.

REFRACTION

When light hits a surface that lets it through, it bends. This is refraction. The obvious example to use is water: if an object is breaking through the surface of water,

Hot Tip

Try painting or drawing different objects as they pass through the surface of water in different-sized vessels (or just quick sketches). This will give you a solid understanding of how refraction works.

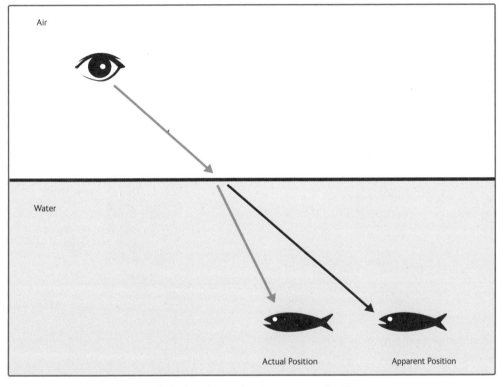

Air

Water

Actual Position

Apparent Position

Above: Refraction refers to the bending of light when it hits a surface. Here, you can see the effects.

perhaps a straw in a glass, the submerged object appears shallower than it is because the light changes angle at the surface.

DIFFRACTION

Similar to refraction, diffraction is the bending of light as it passes around the edge of, or through a gap in, an object. The amount of bending depends on the size of the ray of light in relation to the gap it is passing through. Through a narrow gap, the bending of light will be much more noticeable than through a larger gap; through a small gap, the light will

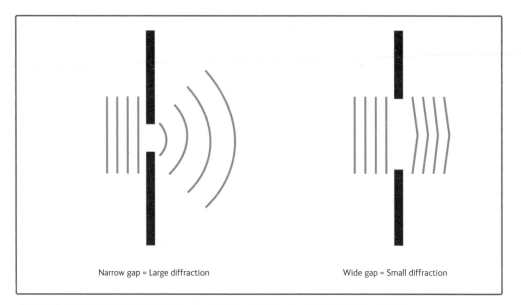

Narrow gap = Large diffraction Wide gap = Small diffraction

Above: Diffraction is the slight bending of light as it passes around the edge of, or through a gap in, an object.

diffract more and spread as it passes through. Try standing in a dark room (with a light on in the next room) and closing the door gradually to see the effects.

INTERFERENCE

Interference, as its name suggests, is when two light sources meet and interfere with each other. It is easier to visualize by thinking of light as water. If you touch calm water with your finger, ripples appear. Touch again, creating two ripples, and where they touch each other, some ripples join together, while some cancel each other out. These are called constructive and destructive interference.

Hot Tip

When painting any kind of spectral effects, it's important to understand the reaction of light to a particular surface, so take pictures and study liquids and gases as much as you can.

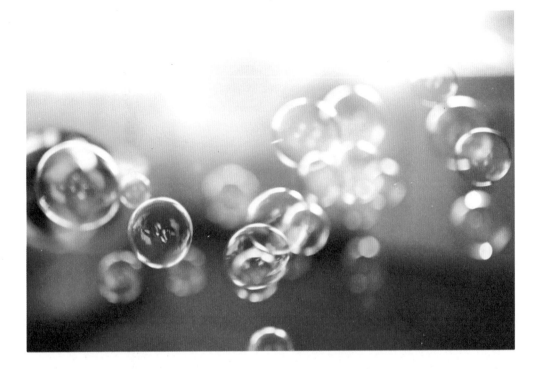

Applying This to Light

When light hits a bubble, some of it bounces off and some passes through the film. So one light wave passes in, two come out (and are no longer travelling at the same speed). So, just like on the water, the two waves start merging. The effect of the colours on the bubble are caused by some of the white light disappearing, leaving the other colours behind. The thickness of the film causes the colours to change across the surface. This is known as thin film interference.

ATMOSPHERIC OPTICAL PHENOMENA

If your paintings involve outdoor scenes or even fantastical visions, it is important to understand how atmospheric phenomena are caused. Knowing the rules of light enables you to depict them convincingly in your scenes. Here are just a few:

○ **What causes a rainbow?** A rainbow is caused by reflection and refraction of light in water droplets. Light is refracted when entering the droplet of water (as water is denser than air), then reflected inside and refracted again when it speeds up on leaving the droplet. Colours appear when some wavelengths are bent more than others when the light enters the droplet – violet is the shortest wavelength of visible light and bends the most. When the light exits the water droplet, it is dispersed into its wavelengths (or colours).

○ **What is an aurora?** Seen above the magnetic poles of the northern (borealis) and southern (australis) hemispheres, these beautiful skyscapes are caused by the collision of gaseous particles in the Earth's atmosphere with charged particles released from the sun's atmosphere. The light is formed – just like in a fluorescent tube – by the charged particles 'exciting' the particles in our atmosphere.

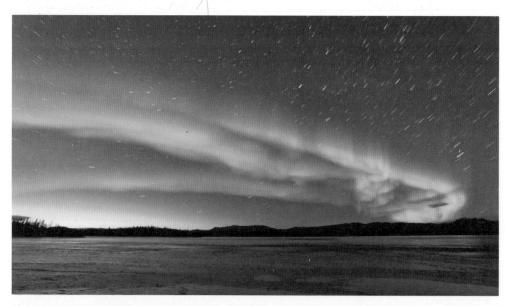

Above: An aurora is caused by charged particles from the sun's atmosphere 'exciting' those in our atmosphere.

○ **Why is the sky blue?** Predominantly, the Earth's atmosphere is made up of oxygen and nitrogen molecules. The longer wavelengths (red, for instance) pass through these, but the shorter wavelengths (violet, indigo, blue and green) are reflected. That's why we see a blue sky (similar to why we see blue oceans). Imagine if a planet's atmosphere was made up of different molecules. What colour would it appear to be?

○ **Why are clouds white?** Simply put, clouds are white because their water droplets are large enough to scatter the entire visible spectrum. For more explanation on this, *see* 'Why Does Something Appear a Colour?' on page 20.

○ **What causes the colours of a sunset?** When the sun is low on the horizon, its light passes through more air than during the day (when the sun is higher in the sky). This air – or atmosphere – means that there are more molecules to scatter the violet and blue light away, with the other colours getting through (red, orange and yellow).

○ **Why do stars twinkle?** Simply put, stars twinkle because of refraction. As the light travels through our atmosphere, it is bent slightly from moment to moment.

COLOUR AND LIGHT

We have already explored the relationship between light and colour, but here we will look at it in a little more detail. For instance, why does an object appear a colour, which colours combine to create white light and how is this different from paint?

WHY DOES SOMETHING APPEAR A COLOUR?

Objects appear to have colour since they absorb and reflect certain wavelengths (colours) of visible light. The colour of something depends on its material. For example, ripe tomatoes contain a pigment (things that absorb light in the visible spectrum are called pigments) called lycopene, which absorbs most of the visible light spectrum, but reflects mainly red.

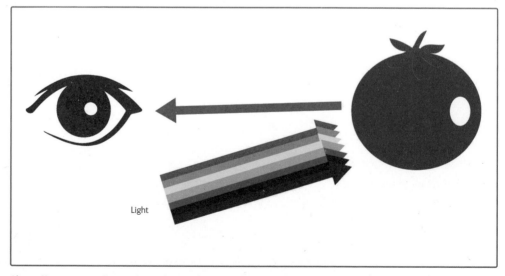

Light

Above: Objects appear to have a colour as they are absorb and reflect certain wavelengths of light.

Another way to think of it is if an object absorbs all wavelengths, it appears black; if it reflects all light, it appears white.

LIGHT EFFECTS

The explanation above assumes that white light is being shone on to the object. If you shine, say, a blue light on to a red tomato, it will appear black — as the blue light is being absorbed and there's no red light to be reflected.

PRIMARY COLOURS OF LIGHT

White light itself is made up of wavelengths, each with a different colour. In order of length (shortest to longest), they are: violet, indigo, blue, green, yellow, orange and red. We have already discussed how different molecules and pigments reflect some wavelengths and absorb others, making them appear a colour. The primary colours of light, however, are red, green and blue (hence RGB). Mixing these in different proportions makes all the colours of light we see – and is how computer screens work. When light is mixed together, it is called additive mixing, and if you shine red, green and blue lights on to a surface at the same time, you will see white.

Hot Tip

It is important as an artist to study theories of visible light and the wavelengths (colours) that make it up. Although having a reference when painting is invaluable, knowing these rules and how to break them in your artwork will help your paintings be convincing, even if they are fantasy scenes.

HOW THIS DIFFERS FROM PAINT

As an artist, you will know that mixing paints or inks doesn't work like this – in fact, it works in the opposite way and is called subtractive mixing. Each colour of paint is absorbing and reflecting colours (like any other object), and the more colours mixed together, the more are absorbed and fewer reflected. The primary colours for paints or printer inks are yellow, magenta and cyan, and if these are mixed together, you get black (or key – hence CMYK).

LIGHT, COLOUR AND MOOD

Lighting and colour can have a dramatic effect on the mood of your painting. In the next chapter, we will look at this in more detail, along with a variety of artistic techniques for capturing different emotions and feelings in your artwork.

Above: White light is made up of different colours.

APPLYING LIGHT

TYPES OF LIGHTING

So now you know a little more about how electromagnetic radiation behaves – or light, as it is more commonly termed. We now look at how artists apply these observations. Let's begin by familiarizing ourselves with the common lighting types you will find in most 2D- and 3D-generated artwork, the principles that help define them and their practical results.

FRONTAL LIGHTING

This is when the artist depicts a light source that is positioned behind the viewer, leaving very little shadow. One characteristic of this approach to lighting a subject is that it leaves a subtle shadow at the form's edges. This can be depicted as an outline that varies in weight.

> ### Hot Tip
>
> If you've invested in an art tablet – like a Wacom – this will allow you to assign certain brush properties, including pressure, to the stylus. This is great if you need to change the weight of a line as you apply the stroke.

THREE-QUARTER LIGHTING

Probably one of the most used ways to light a subject, especially in portraiture, this gives the artist more modelling factors to work with whilst also being flattering to the subject. This approach helps to illuminate features of the subject, but also allows for form-describing shadows.

The light source is commonly low enough to light both eyes, aiding viewer engagement. Should the source illuminate the foreshortened side – creating a nose shadow that falls over the shaded side of the face – this is known as Rembrandt lighting, characterized by a triangle of light left on the shaded cheek.

Above: Of all the lighting types, three-quarter light is one of the most commonly called upon.

Above: Rembrandt lighting illuminates the face from a source of low light, keeping one side of the face in shadow.

Above: Here, the rim light is used to force an outline, which accentuates the lips and neckline.

EDGE (RIM) LIGHTING

A great way to separate your subject from its background, edge lighting occurs when the light source is located behind the subject, and is typically quite strong. On hard surfaces, it can lead to quite a graphical breakdown of features; on other surfaces, you get subsurface scattering (see page 33) as the light leaves the edge.

CONTRE JOUR

A form of back lighting – you can think of the results as the opposite of frontal lighting – this technique can help enhance the silhouette of your subject, making the subject easier to read at a distance.

As the source rays of light push past the subject towards the viewer, a soft, ethereal bleeding of light softens the edge of the subject. This is an effective technique used in editorial illustration, as the near-white background can marry well with the white of the page, creating a vignette.

Above: Edge details are lost to the contre jour lighting effect, giving the subject an aura-like glow.

Above: A light source below the face will create a sinister look.

BELOW LIGHT

Being an uncommon lighting type in the natural world, this technique is loaded with impact. Shadows on a face occur in unusual places and can create a sinister look. Considering the source is often man-made, it is important to remember the interplay of reflected colour on the subject.

SPOTLIGHT

This is usually a single light source that is used to target the subject or to draw the viewer's focus to a specific point within a composition. If you introduce a secondary

spotlight on a subject and the shadows can double up and overlap. If these strong spotlights are coloured, the hues will be represented at the edges of their corresponding shadows.

BOUNCED LIGHT

As light rays hit an object and bounce back off – with some hues being absorbed and others reflected – it is easy to understand how a hard, reflective surface can also become another coloured light source. Applying this observation to your art can elevate your images and create original, unexpected effects.

Bounced Light Expanded

A solid understanding of how light works will help you appreciate what is happening when we look at bounced (or reflected) light. Furthermore, once you understand what is occurring when light is bounced, you can start to predict how light will behave in other situations.

It is also a great place for us to further unpack the physics of light, whilst covering some techniques that can really help to push your digital art forward. When we observe bounced light, it falls into two basic camps – specular and diffused (as we explored on pages 13–14). Here's a recap:

Hot Tip

Bouncing colour into the shadows demonstrates a keen attention to detail, and it really helps to stop thinking of shadows as black or darker versions of the local colour – even with occlusion shadows (*see page 71*). Try assigning a hue to the blacks of your value paintings early in the colour application process. You can use Photoshop's Selective Color Adjustment Layer to directly target the blacks (and neutrals) of an image, adding or subtracting percentages of cyan, magenta and yellow in a subtle yet effective fashion.

- **Specular reflection**: As light rays hit a hard, smooth surface at one angle, the light is consistently reflected off along the opposing angle. The angle at which light is reflected is dependent on the angle of the surface it is being bounced off. You need to imagine this bouncing of light happening on a microscopic level. This helps to understand diffused reflection.

- **Diffused reflection**: A rough surface can also reflect light, but there are more (microscopic) angles, which send the reflected light in various directions. The results of diffused light are more subtle, and prone to a shorter fall-off.

Bouncing Colour

Remember to look for opportunities to bounce colour into your shadows and on to other adjacent surfaces, as this will help tie together colours found elsewhere in the palette. Not only does this mimic what we observe in the real world, it also adds a sense of harmony to an image. A painting is an assortment of abstract 2D shapes of colour and value; you should be looking to unify them so the viewer fully accepts the image before them and doesn't find aspects visually jarring.

Above: There are several moments of bounced colour occurring in this image, made more apparent in the shiny plastic surfaces of the eyes and beak.

REFLECTION AND REFRACTION: THROUGH THE EYES OF THE ARTIST

Commercial artist and designer and co-author of this book, Paul Tysall talks us through his application of reflected and refracted light in his concept art piece: *Aptitude*.

1 **Specular highlight:** This is the brightest (sometimes termed 'hottest') point of reflected light on a surface. The value is very pure, so I used a solid opacity setting with my brush.

2 **Reflected light**: Without this reflected rim light, the lower half of the arm would fall into shadow. Its inclusion helps establish the arm's depth from the torso. The source is a power supply that is emanating a blue glow; this blue is present on the hand, but is prone to fall off the longer down the arm it travels.

3 **Caustics**: As light passes through the ornamental, transparent shards of glass hanging from the subject's armour, it is refracted and sent out to the nearest surface. In truth, I think the direction of the reflected light here is off in relation to the key light, but I wanted to use it as a device to illuminate the ornate embroidery found on the lower half of her uniform.

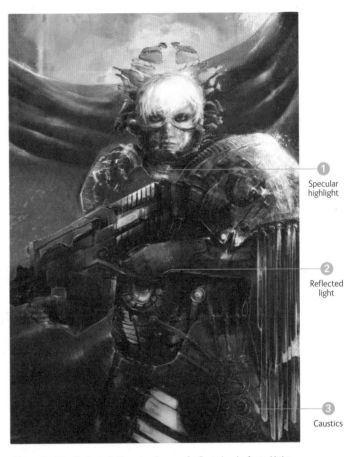

1 Specular highlight

2 Reflected light

3 Caustics

Above: Paul Tysall's *Aptitude* illustrates the use of reflected and refracted light.

SUBSURFACE SCATTERING (SSS)

Light physics can lead to some very complicated interactions with various objects and surface types, but once you understand what is happening – and can recognize when and where to exploit these interactions – your digital art becomes more anchored in reality, and even the most fantastical scene can appear more real.

Light Interplay

A wonderful observation of light interplaying with certain surfaces can be found in subsurface scattering – the by-product of light entering a semi-opaque (translucent) surface, bouncing around and being emitted back out. So the outcome is a mix of both reflection and refraction.

Human Torch

Holding a torch directly to the flat palm of your hand, so it is in contact with your fingers, you can observe the light of the torch entering the semi-opaque skin: some of the light rays are absorbed, whilst other rays reflect off blood cells and exit the skin. What we are left with is an orange glow amplifying the rim light.

Above: When a torch is held up to our skin, some light rays will reflect off, leaving an amplified glow.

APPLYING COLOUR

Now that you are developing an understanding of how light behaves, and identifying how certain surfaces react to light, let's look at the practical application of your observations.

WORKING IN VALUE BEFORE APPROACHING COLOUR

One of the most appealing aspects of digital art is it affords you the chance to break down the entire painting process in a non-destructive way. A common approach, whether working in 3D or 2D, is to construct an image based on value first. This is describing how the light and shadows are interacting to describe your subject, working in degrees of grey from black to white (greyscale), without the direct application of colour.

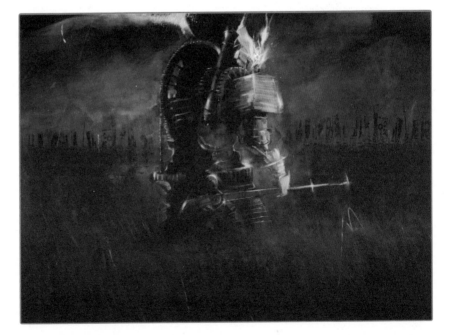

Right: This image started as a rough value painting, and through the use of layers and blend modes, it was worked up into colour.

From Value to Colour in Photoshop

1. **On a new layer**, select a brush (there are a wealth of brushes to select from; we recommend beginners start with a hard, round brush) and start to describe your image. It might be handy to work with a reference image that has already been changed to greyscale. Remember to change the size and opacity settings of your brush (keyboard shortcut: 'B') as you paint, so there is some variation to your marks. Remember too that if you are using a tablet, its pressure sensitivity helps with varied strokes.

Hot Tip

If you are using 2D digital imaging software, we recommend using the HSB sliders to select your colour as you paint. You have sliders to affect the Hue (the local or reflected colour of choice), the Saturation (remember that colours are more saturated in shadows) and the Brightness (which determines the value of the colour).

2. **Now add three new layers**. Change the blend mode of the first layer (above
 your value painting) to **Color**. The layer above that needs to be changed to **Multiply**,
 and then the final one to **Screen**. The colour blend mode allows you to paint
 in a hue whilst retaining the values beneath – essentially creating local colour.
 You can use the Multiply mode to suggest shadows and the Screen layer to
 lighten parts.

3. You should see this method as a starting point only, as the results are far from
 perfect. As it stands, your image is only describing colour in terms of value, and
 doesn't really make much sense to how we perceive light and colour in the real world,
 which we shall expand upon later. What you have done, however, can be combined
 with the **Adjustment Layer techniques** we look at on pages 78–82 to generate a
 preliminary colour base-paint.

ENHANCING YOUR COLOUR

Once you've got a rough colour version, there are several colour enhancement techniques you can apply to move things forward. Try experimenting with the Adjustment Layer techniques we discuss on pages 78–82, but don't get too carried away with them. Save a copy of your work, then flatten the image and begin to build up the painting with more brush marks. Now that you have hues to work with, select colours from within the painting using the Eyedropper Tool (this is the Alt key whenever you have a brush selected, or 'I' if you don't).

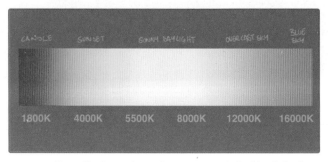

Above: This diagram shows colour temperatures in the Kelvin Scale – from candlelight to blue sky.

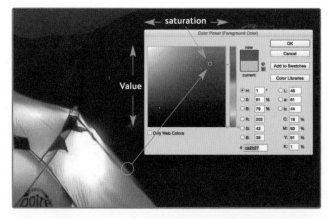

Above: In the shadow parts of an image, the value and the saturation are both higher.

COLOUR TEMPERATURE

Very briefly study the diagram here. What you are looking at is visible light (from a black-body radiator) represented in degrees Kelvin. Fascinating, but what does it mean? This is how colour, a result of electromagnetic radiation (light), is viewed in the real world. The best way to understand this is to open a photograph of coloured light sources in Photoshop. If you open the Color Picker, you can sample areas within the image. What you'll notice is that, say, on a red light, the brightest point is white, but then it will quickly shift into yellow, then orange, before settling on the local colour of red.

Color Picker

Move the Color Picker around in the shadow parts of an image and you

should notice that not only does the value get darker, but there is also more saturation. So as a blue shadow deepens, it becomes more purple in hue.

Applying Colour

Begin to apply colour in this way. If you stop thinking that a colour in shadow is just a darker version of that hue, your art will start to become more vibrant and suggestive of what is really happening when we view our surroundings.

INTRODUCING THE SOFTWARE

DIGITAL PAINTING AND IMAGE EDITING

There are many, many 2D digital painting tools out there, including a healthy selection for iPad and other mobile devices. Here we look at some of the best.

Hot Tip

For the Lighting Effects tool in Photoshop, simply head to the Filter Menu. These lighting effects can make a powerful impact on your art.

ADOBE PHOTOSHOP

Photoshop is the de facto standard tool for digital painting, image editing, and lighting and art effects. The application has an expansive, completely customizable brush set that enables you to not only lay on natural-media effects, but also paint on complex lighting effects using blending modes, masks and more. And Photoshop is the ideal post-processing tool. Its toolset includes bright/contrast controls, levels and curves and much more. Anything you can imagine is pretty much possible in Photoshop.

A One-stop Shop

In addition, head to the Filter menu for a dedicated Lighting Effects tool, with which you can add spot, point and infinite lights, controlling their appearance with sliders. Used in conjunction with Photoshop's masking tools, Lighting Effects can be extremely powerful when adding new looks to your artwork. Even more appealing are Adjustment Layers, which let you add different effects without touching the pixels underneath, meaning you can experiment at will.

In short, Photoshop is an essential tool for any digital artist, especially if you want to work in CMYK colour mode for print output. The application is currently only available as part of a Creative Cloud subscription. It runs on both Mac and PC platforms.

Using Lighting Effects in Photoshop

1. First, **open up the document** that you want to apply lighting effects to. This is most likely a 3D render, but you can get some interesting effects using the Lighting Effects filter on your digital art. Note, if you have imported a 3D model directly into Photoshop, you'll need to go to Filter > Convert for Smart Filters before being able to use Lighting Effects.

2. Go to the **Filter** menu and choose **Render** and then **Lighting Effects**. This opens up the dialogue box with all the lighting controls. You'll see your image appear with a default spotlight over the centre.

3. Here, because we're working with a 3D model on an **individual layer**, the Lighting Effects filter is only affecting that layer. You can use the Lighting Effects filter to tweak the look of an individual layer – perhaps adding a highlight to some armour or blending in a 3D model with a 2D painting.

4. There are two ways in which you control the Lighting Effects filter: the **interactive**
 '**handles**' on the canvas; and the **sliders** to the right of the interface. Start with
 the default sliders and then drag the handles on the canvas, making the spotlight
 bigger, and therefore less intense. Doing the opposite will up the intensity and
 focus – just as if you were moving a torch closer to an object. You can also rotate
 the light.

5. You can **change the type of light** using the drop-down menu to the top-right of the
 dialogue box. Experiment with **Point**, **Spot** and **Infinite** lighting types. Finally, use the
 self-explanatory sliders to change the colour, Hotspot intensity and other light attributes.

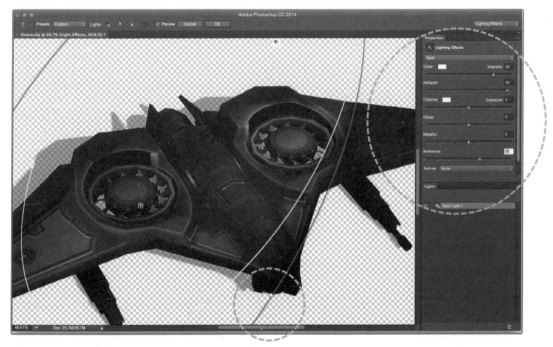

Above: Use the Lighting Effects handles and sliders to make subtle – or dramatic – lighting changes to individual layers or complete
artwork in Photoshop.

COREL PAINTER

If it is a dedicated digital painting tool you're after, there is nothing better than Painter. Painter, now owned by Corel, has a rich history and a toolset to match. Painter is one of the leading applications for concept artists and those working in the entertainment industries, and its brushes are – bar none – the best out there.

Three of the Best Brushes in Painter

Whether you want to simulate a thick, oily highlight or a subtle change in tone in watercolour, Painter has a brush – and a vast number of controls – to do it. The application also has a number of image-editing tools – such as Dodge and Burn – enabling you to fine-tune and post-process your brushstrokes.

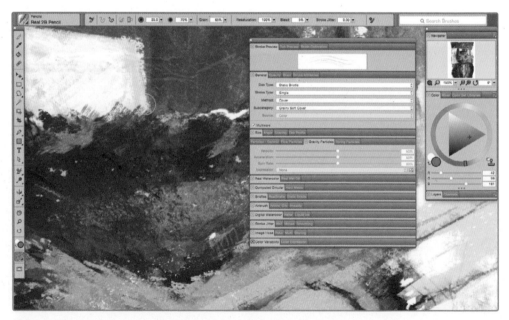

Above: Corel Painter is the best tool for simulating natural media effects such as oils, watercolours and acrylics.

In the latest release – Painter 2015 – there are some rather nifty Particle Brushes for creating stunning lighting effects, along with a real-time preview option and, of course, almost endless combinations of brushes, paper textures and media.

> ## Hot Tip
>
> **Any brush settings you edit in Painter can be saved as a brush for use later on. Simply go to Save Variant in the Brush Selector menu.**

○ **Particle brushes:** Particle brushes are great for creating lighting and dynamic, fluid effects. If it is glowing light trails and strong bursts of colour you need – maybe flares coming from a magician's hands – Particle Brushes are great to have.

Above: Painter's Particle Brushes are particularly handy for creating impressive lighting effects.

○ **RealBristle brushes**: The cool thing about Painter is its realistic brushes, and RealBristle brushes take this a step further. As you paint on the canvas, the bristles move and bend, as a real brush would.

○ **Jitter brushes**: Jitter brushes enable you, via extensive controls, to make your brush change dynamically as you paint – creating a controlled yet random stroke. This is great for adding realism and randomness to your highlights, say, when finishing a piece.

GIMP

GIMP – or the GNU Image Manipulation Program – is a popular and indeed free image-editing and manipulation program. For a free piece of software, GIMP is an incredibly powerful tool for artists, whether you want to paint directly in the application or add numerous lighting and post-processing effects. GIMP enables you to create your own brushes from your canvas, as well as comprehensively edit those available in the program's palette.

Free ... and Powerful

It is not as complete in its functionality as, say, Photoshop (as you would expect), but it is an incredibly good tool for those on a budget of, er, zero and includes excellent layer functionality, including masking tools and blending modes. In addition, there is a whole filter set called Light and Shadow, enabling you to quickly apply gradient flares, lens flares and even supernova effects. Download it from www.gimp.org.

Three Top Lighting Features of GIMP

- **Sparkle:** This effect enables you to apply sparkles to your images and includes the ability to tweak luminosity, flare, number of spike points and more. Used subtly, it can be good for adding highlights.

- **Supernova:** Less subtle, this filter effect creates a dramatic, bright star (hence the name). You can change the colour, radius, spokes and hue, as well as precisely position the centre of the star.

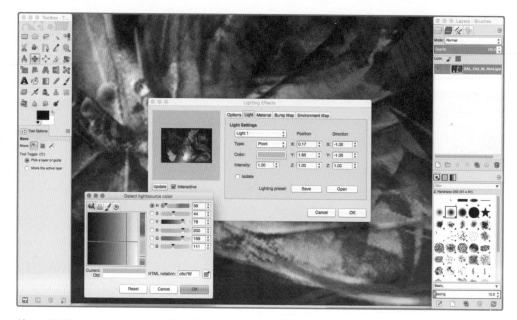

Above: GIMP has some excellent lighting effects filters, enabling you to add special effects to your artwork.

○ **Lighting effects:** Like Photoshop, GIMP enables you to add spotlight effects using simple sliders and interactive controls. You can even save presets for quickly applying your favourite lights to an image.

Creating a Custom Brush in GIMP

Custom brushes are a great way to add interest to your artwork, and for fine-tuning highlights and shadows. In GIMP, you can create a custom brush from any element on the canvas.

1. First, **select** the part of your image you want to turn into a brush, using a rectangular or elliptical selection.

2. Next, **copy** it and then go to the **Brush palette**, where you'll see the selection as a brush named 'Clipboard'. **Rename** this.

3. You can also **create a brush by creating a new image** at 35 pixels in greyscale, filling with white and then drawing your shape in black. Save the file with a .GBR extension and place it in the .gimp-2.8/brushes/folder. Refresh brushes using the button in the Brushes palette and you are ready to use it.

Above: GIMP is an incredibly powerful digital painting and image-editing tool that can be downloaded for free.

AUTODESK SKETCHBOOK PRO

Sketchbook Pro, as the name suggests, is predominantly a sketching and painting application, aimed at illustrators and artists wanting to get their ideas into digital form as quickly as possible. That said, thanks to a vast number of illustration tools, including custom brushes and an intuitive, artist-led interface, the tool can be used to create finished artwork.

Sketchbook Effects

Sketchbook Pro really isn't about effects (although you can use layer blending modes to build up lighting and tonal effects, as well as adjust images using brightness/contrast, hue/saturation/lightness and so on). It is more about using the excellent natural-media tools to build up effects, just like working on paper with traditional media. Sketchbook is available free in the Mac App Store, with subscription in-app purchases enabling you to unlock the full feature set. It is also available for Windows from www.sketchbook.com/desktop.

The Sketchbook Pro Interface

The Sketchbook Pro interface is aimed at artists wanting less clutter and more canvas.

1 The **canvas** is where you paint – and Sketchbook Pro has a large, expansive canvas that enables you to focus directly on your artwork.

2 The **Tools** panel enables you to quickly flip between different tools in Sketchbook Pro, including brushes, selection, zoom tools and so on.

3 The **Layers** panel enables you to build up elements of your canvas, adding different blending modes to create interesting and realistic lighting effects.

Canvas Tools Panel
1 **2**

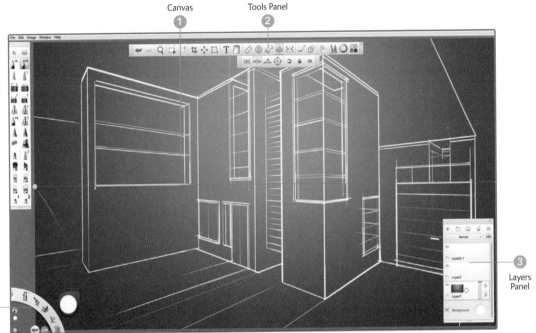

3 Layers Panel

4 Lagoon Panel

Above: The uncluttered Sketchbook Pro interface.

④ The **Lagoon** panel is unique to Sketchbook Pro and is a fantastic way of quickly selecting tools and colours – especially when using a stylus. It can be pinned to different areas of the interface.

ARTRAGE

Like Painter, ArtRage features a plethora of natural-media tools for creating realistic paint effects, and like Sketchbook Pro, it features an easy-to-use interface that is aimed squarely at artists who want to paint and not be bothered with configuring panels. ArtRage 4, at only £30/$49.90 for Mac or PC, is a real bargain and the tools on offer feel great to use with a stylus. The Oil Brush, Paint Tube and Airbrush are all excellent, and as you work in the application, it feels like the traditional media equivalent.

Above: ArtRage features an easy-to-use interface.

More For Your Money

There are also loads of paper texture options, special effects tools and layer functionality – the last meaning you can use blend modes to build up your lighting and tone with ease. Visit www.artrage.com for more information.

ArtRage for iPad and iPhone

As well as a desktop version of the software, there is excellent Photoshop integration and the app is also available on iPad and iPhone, meaning you can start your work out and about and finish it in the studio (or vice versa).

Using Layers in ArtRage for Lighting Effects

1. After installation and opening up the software, the Layer panel may not be visible. To load it up, go to the **View** menu and choose **Layer panel** from the options that appear.

2. Whilst it may look simple, the Layer panel holds a lot of functionality. To begin adding highlights (or other lighting/tonal effects) to your artwork, **create a new layer** by hitting the + button at the bottom of the panel.

3. Next, hit the **menu icon** at the bottom of the Layer panel and hit the **Blend Mode** option. In the list that appears, choose **Screen**, and with a white or light brush, start painting your highlights (or indeed strengthening them).

4. Flick the blending mode back to **Normal** to begin to understand how the blending mode is affecting your paint. Experiment with other blending modes – such as Multiply for strengthening shadows – to start to build up your lighting effects.

> ## Hot Tip
>
> Rename your layer groups in ArtRage by going to the Layer panel, selecting the layer group's menu icon and choosing Set Group Name. You can also edit the opacity here.

Above: A great-value painting tool, and available on desktop machines as well as mobiles and tablets, ArtRage is packed full of features.

Above: ArtRage is available for Mac and PC as well as iPad and iPhone, and is a fantastic application aimed at artists wanting a simple yet powerful painting tool.

5. You can also **group layers** in ArtRage – handy for putting all highlight layers in the same group and accessing them quickly. Simply go to the **Layer panel** menu and choose **Add Layer Group**. Drag your layers into the new folder in the Layer panel to group them.

SAVAGE INTERACTIVE PROCREATE

Procreate isn't a desktop application – it is only available for iPad – but due to its huge number of features that benefit digital artists, it is worthy of a mention here. The interface is very minimal, enabling the artist to focus on the canvas, and the brushes on offer are neatly organized into sketching, inking, painting and other easy-to-understand categories. This comprehensive art tool for iPad should be high on your list of portable drawing apps.

Top Features of Procreate

- **Brushes**: There are 120 brushes built in, but each brush has over 25 adjustable settings, meaning you have ultimate control over your strokes (and naturally, you can create your own brushes as well).

Above: Procreate is a digital painting app for iPad, with a host of exciting and intuitive features.

- **K support**: Procreate enables you to work on canvas sizes up to 4096 x 4096 pixels (4K).

- **Filter effects**: The app has some wonderfully intuitive filter and lighting effects that can be applied by dragging over the canvas (and you see them applied in real time).

- **Layers**: Even though it is an iPad app, Procreate has full layer functionality – meaning you can apply lighting effects and tweak colours using blending modes such as screen, multiply and colour burn.

PROJECT DOGWAFFLE HOWLER

Project Dogwaffle Howler (PD Howler) is a little-known yet excellent painting and effects tool for Windows. Yes, it has a strange name, but it also has a variety of brush- and effects-based features for digital artists and those working in the entertainment industries.

Above: Whilst it may not be that well known, PD Howler is a fantastic tool for editing and creating digital imagery.

Whilst the application may be a little unfamiliar if you are used to the likes of Photoshop, for creating cool effects – and particularly adding dynamically lit landscapes as backgrounds to your paintings – PD Howler is worth a look.

PD Howler's Best Features

- **Foliage:** These very cool and useful brushes enable you to quickly 'grow' trees and plants in faux-3D – complete with built-in lighting effects – on your canvas (all set up by simple rule-based sliders).

- **Custom brushes:** PD Howler is a powerful natural-media painting tool and includes bristle brushes, particle brushes, brushes under the influence of force fields and much more.

- **3D Designer**: This innovative tool enables you to take a 2D image and quickly extrude it to create complex landscapes – complete with atmospheric lighting effects. It is a simple way to build stunning 3D topography.

- **Filters and effects**: PD Howler has some great filters, enabling you to add special lighting effects to your artwork. These include Plasma noise, Radiant, Sky and Starfield.

Hot Tip

Project Dogwaffle Howler also features a great animation toolset, meaning you can animate lighting effects using a familiar timeline-based interface.

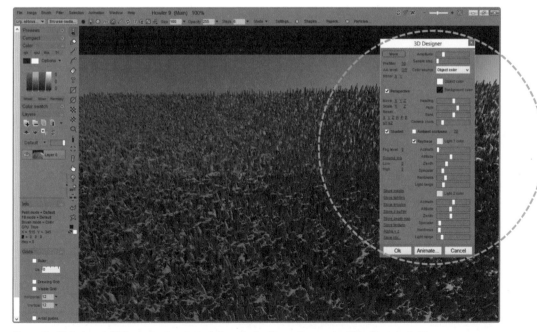

Above: The 3D Designer in PD Howler is extremely simple to use and makes creating complex 3D landscapes a cinch!

3D MODELLING AND RENDERING TOOLS

3D tools are complex to learn and often expensive, but if you put in the effort, you will be able to create some stunning imagery. Here, we look at some of the applications available.

MAXON CINEMA 4D

Cinema 4D is a feature-packed and great-value modelling, texturing, rendering and animation tool. If you are looking for an easy route into 3D modelling and lighting techniques, it is a great place to start. Modelling-wise, the application has a professional toolset, including powerful features for cutting, joining and manipulating 3D objects.

Powerful Realism

In short, if you are after an application that delivers a huge amount of realism in its renders, ultimate control over lighting in a scene and a cracking 3D toolset to match, Cinema 4D is worth checking out. Cinema 4D starts at £720/ $1100 for the Prime version. Find out more about its top-end lighting tools at http://www.maxon.net/products/cinema-4d-studio/advanced-lighting.html.

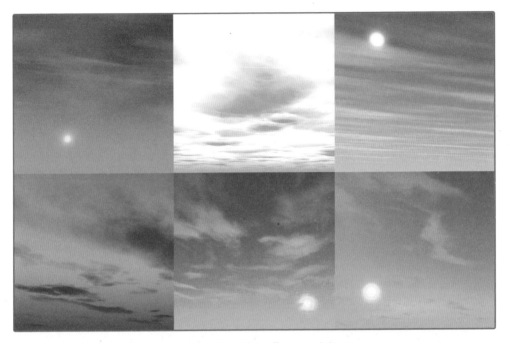

Above: Cinema 4D's Sky tool enables you to create atmospheric lighting effects in very little time.

Lighting in Cinema 4D

The lighting tools are excellent in Cinema 4D. After creating a light effect, you can control colour, brightness fall-off and many other properties, as well as adjust the density and colour of each light's shadows. In addition, there is a fantastic Sky tool in the Studio version of the application, enabling you to create stunning atmospheric lighting effects. Tight integration with Photoshop enables you to tweak individual layers in Adobe's application after rendering in Cinema 4D.

Hot Tip

Name your lights. When creating many lights in a 3D application it is easy to lose track of them. Make sure you name your lights, perhaps by the type of light they are and what they are illuminating.

AUTODESK MAYA

Maya is widely regarded as one of the best 3D animation tools on the market, and it is also fantastic for creating still, beautifully lit and rendered 3D scenes. Maya has, as you would expect, an extensive modelling, dynamics and effects toolset, complete with the world-renowned Maya Fur and Fluid Effects. You can also use brush-based tools to paint textures directly on to models in the application.

Feature-packed but Costly

There is far too much to this exciting and somewhat intimidating 3D application to mention here, but rest assured, whatever you want to create, Maya will enable you to do it. Maya is, as you'd imagine, pretty costly as well; at £160/$250 per month, it's for serious users only. Find out more about its toolset at www.autodesk.co.uk/products/maya.

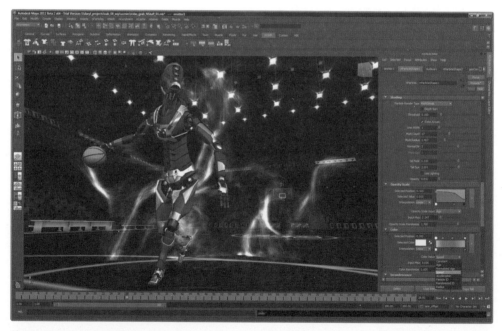

Above: Maya is a complex, professional 3D tool. To make the most out of it takes investment in time and money.

Above:3ds Max is a modelling and rendering tool that enables artists to simulate many different natural and artificial lighting effects.

AUTODESK 3DS MAX

3ds Max by Autodesk – the same company that makes Maya and many other high-end 3D tools – is a full-on 3D modelling, animation and rendering suite aimed at game artists, visualization specialists and visual effects artists. Its lighting tools are comprehensive (including the ability to simulate and analyse sun, sky and artificial light) and its renderer is one of the best out there.

But again, like Maya, learning 3ds Max and the intricacies involved is not an easy task, and you must be ready to put a whole load of time and effort into the program. If you master it, it will reward you with photorealistic, beautiful renders. 3ds Max has a price to match its feature set, and currently retails at around £3,800/$5,900.

Above: As Blender is free and hugely powerful, it enables you to get started in 3D lighting techniques with no cash investment.

BLENDER

From the expensive to the inexpensive – well, free, actually. Blender is an open-source 3D modelling, animation and rendering application and the perfect place to start if you are new to 3D techniques. Available for Mac, PC and Linux, there is no excuse not to get Blender and play around with its brilliant feature set.

Its photorealistic renderer is excellent (complete with HDR lighting support), its lighting and material features are similarly good, and its ability to create accurate simulations of fluid, smoke, rain, sparks and more will add a new dimension to your artwork. We are not saying you will learn Blender overnight, but when a tool this good is free, what is stopping you? Find out more at www.blender.org.

WHAT WORKS FOR YOU

Of course, there are many more tools than the ones we have mentioned. This really is just an introduction to the software you need to get started with digital painting, 3D and creating brilliant lighting effects in your images.

Hot Tip

Use colours. Using lights with colours can add a whole new dynamic and emotional meaning to your scene – so experiment!

Which application, or applications, you choose is really dependent on your own personal preference (and budget). Artists use tools that they can easily navigate and find intuitive to work with. Many of the applications here have free trials, so experiment with what works for you.

CORE LIGHTING SKILLS

BASIC SHADOWS AND HIGHLIGHTS

Shadow and light are the fundamental principles of form description in all aspects of drawing, painting, photography and digital art. Understanding where and how to place both relies on identifying the location of your light sources in relation to your subject.

THE 3D DIFFERENCE

In 3D packages, this is easy to control by placing lights known as a Lighting Rig around the subject. When painting digitally, if you are not painting from life, a certain amount of imagination is required. This is why you will find most digital artists will scribble directional arrows early on in the blocking-in stage, to indicate where their light sources are situated.

Light Before Colour

One benefit of all digital-art-focused software is you can separate this

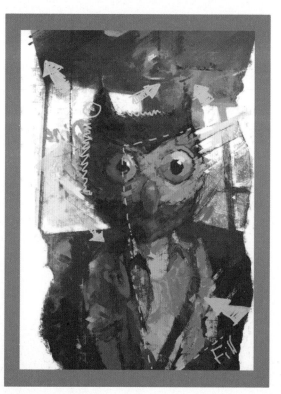

Right: Here, the artist has annotated their value study with arrows to indicate which direction the light is travelling in and which parts of the image will need attention.

important part of the image-creation process out before approaching the tricky subject of colour. In fact, it is good artistic practice to accurately describe the light and shade of your image – known as its values, described in tones of grey from black to white – very early on in the process. This is explored in more detail on pages 76–82.

Tonal Steps

The tonal steps generated by light hitting a geometric object are known as the modelling factors. These are accentuated under direct (sunlight) lighting conditions. The annotated image on the following page explains the fundamental terms and their relationships.

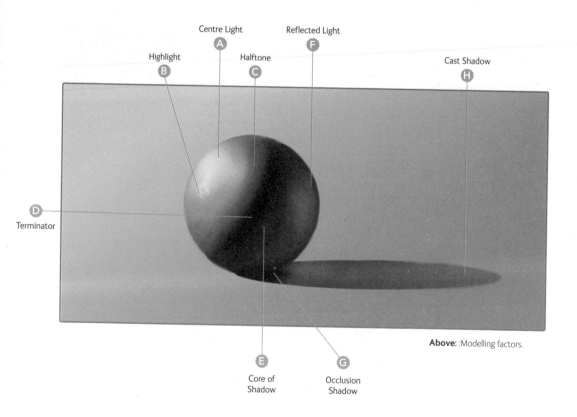

Centre Light **A**

Reflected Light **F**

Highlight **B**

Halftone **C**

Cast Shadow **H**

D Terminator

E Core of Shadow

G Occlusion Shadow

Above: :Modelling factors.

A **Centre light**: The strongest area of diffuse reflection.

B **Highlight**: The specular reflection of your light source, its strength is dictated by how shiny the object's surface is.

C **Halftone**: The weaker areas of diffuse reflection, where tones begin to darken.

D **Terminator**: The line that denotes the transition from light into shadow, created when the emitted light rays are touching the edge of the object.

E Core of shadow: The area of shadow that follows the Terminator and remains undiluted by a reflected secondary source light.

F Reflected light: As light bounces off surrounding surfaces, it will find its way into shadows.

G Occlusion shadow: This is the absence of light when objects are in contact and form a dense shadow.

H Cast shadow: The projected shadow created by light rays being blocked by an object.

Hot Tip

A worthwhile exercise is to take a digital image file of a photograph or a painting and change the image mode from RGB to greyscale, and then identify the modelling factors using your own annotations. Once you can recognize them, engineering them within your images will become a lot easier.

WARM AND COLD HUES

The temperature associated with colour is a purely psychological phenomenon, which means it can be a very effective way to imbue an image with emotion. We tend to think of reds and yellows as warm, welcoming hues, so using them in a positive context will help the viewer connect on an emotional level.

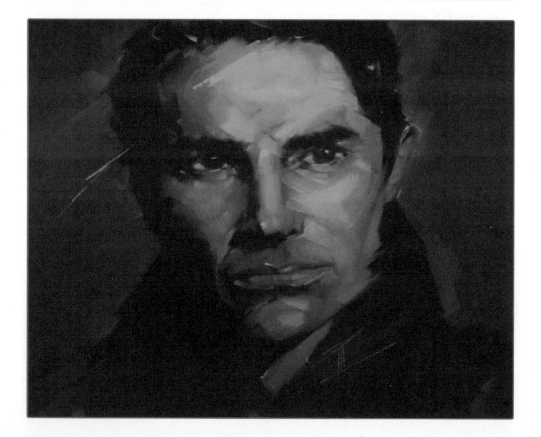

PHYSICAL EFFECTS

Some colours even have a measurable, physical effect on us, for example, red increases the heart rate. With an increased pulse, the metabolism speeds up – now you know why restaurants like to use red in their decorative schemes.

Colour Perception

Because so much of colour theory is associative, predominantly with our perception of the natural world, as an artist, you can deploy colour to achieve specific visual goals. We think of cold colours as

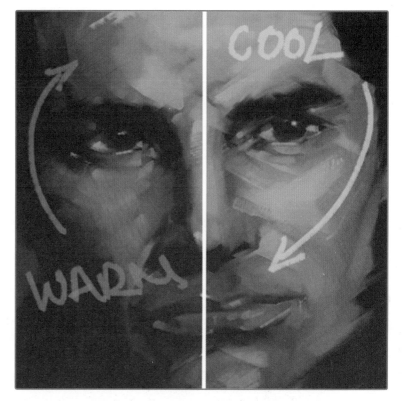

Above: For this imposing character, the original colour treatment was too warm, albeit in a more natural palette. To imbue the character with more detachment, a cooler colour scheme is required.

receding – especially blue, as distant objects in a landscape take on a bluish hue due to atmospheric conditions – and by offsetting with warm colours, you can create a sense of colour depth within a composition.

Using Adobe Photoshop's Color Balance to Cool or Warm the Palette

Obviously, you should be very mindful of the colours you are using throughout the painting process, how they react with each other and the overall emotional feeling your palette is conveying. This said, every professional digital artist will perform a certain amount of end-stage

colour editing using Adjustment Layers – a practice known as 'colour correction' – to enhance the finished image.

1. From the **Layers** panel [F7], select the **Create new fill or adjustment layer** icon and scroll up to the **Color Balance** option.

2. In the **Properties** window is a selection of sliders: cyan to red, magenta to green, yellow to blue. These sliders can edit the midtones, shadows and highlights

Above: Choosing Color Balance to start colour correcting.

Above: In the Properties window you can edit the different tones of the primary colours.

of your image. Choose the relevant option by clicking the Tone drop-down menu.

3. **Slight increases and decreases** in each of these options can shift the overall colour temperature towards the desired outcome. Moderate use can help to apply colour unity within an image by removing existing colours and creating a more restricted colour palette.

Hot Tip

If you find that you are not achieving the right colour temperature early in the colouring stage, or you are still undecided about the direction of the colour palette, try using Color Balance to trial various options.

HIGH- AND LOW-KEY

Another artist's tool used for conveying drama, and also for simplifying the focus of an image, is painting in a high or low key. A low-key image doesn't have many light sources, sometimes only one which is used sparingly to light a specific point within your composition. The values within the image go from mid-grey to black.

HIGH-KEY VERSUS LOW-KEY

A high-key image follows the same principles as above, but the values go from mid-grey towards white. In real-world lighting terms, these values are determined by the amount of fill light used. If you flood the subject with light, details are blown out; flip this around (low-key) and details are lost to darkness.

Using Levels to Plan a High- or Low-Key Direction

Once you have completed a preliminary value study, you can use this method to determine if you want to push the rest of the painting down a high- or low-key direction.

1. From the **Layers** window, select the **Create new fill or adjustment layer** icon and scroll up to the **Levels** option.

2. **Low-key**: Before editing the points on the Levels histogram, drag the Adjust highlight output level slider (the white triangle) along the Output Levels gradient bar to somewhere in the middle.

Hot Tip

In the examples given here, these techniques should be used to establish a direction only. You will need to re-establish your lighting sources, and you will need to repaint the values.

Now, on the main histogram, drag the Adjust mid-tones input level slider (the grey triangle) to the right, towards the highlight output end. This will start to dramatically darken the image. Tweaking both the highlight input and output sliders will help to bring back lighter tones.

Above: Output levels can be adjusted in the Properties window in order to achieve a low-key direction.

3. **High-key:** Start by dragging the Adjust shadow output level into the middle of the Output Levels bar, then drag both the highlight and mid-tones slider towards the Shadow input range.

Normal Value

Low Value

Above: The difference between the choice of a high- or low-key direction for your piece is stark.

ADJUSTMENT LAYERS

Here are a few Photoshop Adjustment Layers worth exploring to improve the lighting results in your digital painting.

USEFUL ADJUSTMENT LAYERS

- **Gradient**: Handy for unifying colours and emulating a half-shadow effect, this is when an artist will light the top half of their subject and allow the rest to fall into shadow, pulling

the eyes' focus towards the top half. You should try various blend modes with this effect, and control the subtlety of the results by lowering the Adjustment Layer opacity.

- **Hue/Saturation**: Using the hue slider can lead to very dramatic shifts in colour, so try to use this sparingly. It is, however, another way to affect the temperature of your image. The saturation settings, on the other hand, can be very useful. It is a common mistake amongst beginners to oversaturate their images with colour; a slight reduction can help normalize the existing hues.

- **Curves**: One of the most common Adjustment Layers for colour correction, applied at the closing stages. A common editing choice is to create a subtle S-curve, deepening the dark values and brightening the highlights.

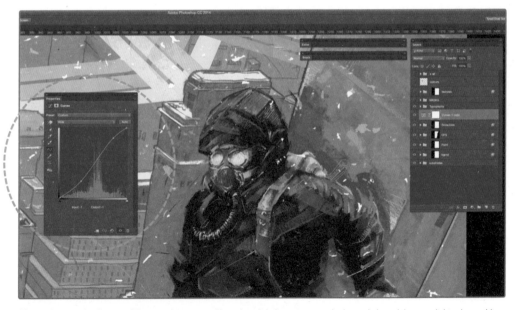

Above: An example of a typical S-curve adjustment in Photoshop. It helps to increase the lower darks and the purer light values, adding a kick to the overall image contrast.

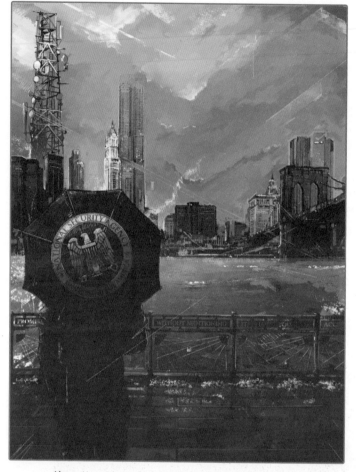

Above: Here, we've used a Gradient Map Adjustment Layer to create complementary shadows.

Selective Color: Another great way to edit your final piece, this Adjustment Layer can be used to target specific hues. You can use a slider to then increase/decrease percentages of cyan, magenta, yellow and black.

GRADIENT MAP ADJUSTMENT LAYER

A Gradient Map can be used to apply hues to the value range of an image. Use the Gradient Map Adjustment Layer in order to create complementary shadows.

Complementary Shadows

Complementary shadows can often be found during what artists refer to as the Golden Hour – sunset. When the sun is low in the sky, the ambient light is tinted with red and orange as the short wavelengths are dispersed. Surfaces in direct sunlight can take on a warm hue, whilst the shadows veer more towards blue. You can assimilate this light and colour effect by using the Gradient Map Adjustment Layer.

Complementary Shadows in Photoshop

Complementary shadows are not consigned only to the realm of landscape painting; the colour contrast effect can significantly affect the impact of any work.

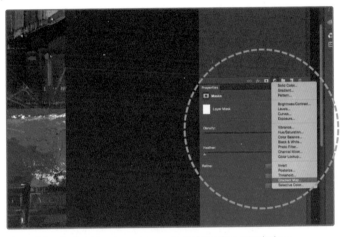

Above: Select Gradient Map... to create a new layer of complementary shadows.

1. Select **Gradient Map...** from the **Create new fill or adjustment layer** icon. In the Properties window, click on the gradient preview bar to open the Gradient Editor.

2. Initially, only the preset gradients are available, but by clicking on the small cog icon, you can add more. Navigate to the **Color**

Above: Color Harmonies 2 is just one of a list of additional gradient sets that can be used.

Harmonies 2 selection – the purple, yellow preset is a good jumping-off point. With this option selected, click OK.

3. Back in the Properties window, click the **Reverse** option. This will send the blue hues into the darker values and assign yellow to the lighter tones. Now change the Adjustment Layer blending mode to **Lighten**. This will bring the original lighter tones back into play. (Note that this blending mode can flatten the tonal range, so try experimenting with others.)

Hot Tip

It is worth going back into the Gradient Editor and finding more natural blues, and even changing the yellow for a more natural orange. (See below.)

BLENDING MODES

When painting digitally, it is best practice to limit the number of blend modes you use throughout your workflow. You should avoid a finished painting that feels 'computer generated' as a result of overusing digital tools and filters. That said, there are some core blend modes that can expedite the painting process.

Above: Keeping track of how many blend modes you use is vital to creating a successful digital painting.

CORE MODES FOR PAINTING

The following Photoshop blend modes are recognized as core to digital painting techniques:

- **Normal:** The default mode of every new layer; edits or painted results are separated from their original properties.

- **Darken:** Looks at the overall colour channel information and retains the darkest pixels of the base and blend layer.

- **Multiply:** Multiplies the base and blended layer together. The result is like adding an ink wash over your base image, which is why Multiply can be used to deepen shadows or add depth to a form.

- **Lighten:** Looks at the overall colour channel information and retains the lightest pixels from the base and blend layer. The result is like adding a glaze, which makes it handy for building up colour over a value painting.

- **Screen:** Multiplies the base and blend layer like the Multiply blend mode, but inverts the outcome. The resulting blended colour is always lighter than the base. This can help with painting highlights.

- **Overlay:** Depending on the values of the base colours, Overlay uses either Multiply or Screen to affect the blend layer. The base colours are not replaced but rather mixed, which makes it an ideal blend mode for bringing colours to a value painting, though in some situations, the results can appear overly saturated.

- **Color:** An extremely useful blend mode for beginner digital painters, as it creates a resulting colour based on the luminance of the base layer, so you can create your base painting purely in values (levels of grey), then begin to apply colour, as you would when glazing in traditional painting.

USING BLEND MODES TO MAKE THE MOST OF IMPORTED PHOTO TEXTURES

It is common practice to import photos to help texture parts of an image. Digital painting can tend to look a little sterile, so whether it is adding an overall texture to your paintings using photos for specific parts (e.g. fabric for clothing) or the entire image area (e.g. using a canvas texture), even adding a slight Photoshop grain will help add bite to the final piece.

Hot Tip

A common misuse of this technique is allowing the texture to come through in areas of shadow, contradicting the physics of light and shadow.

Right: When describing textured cloth, you might want to import a photo of a woven surface, such as a net texture.

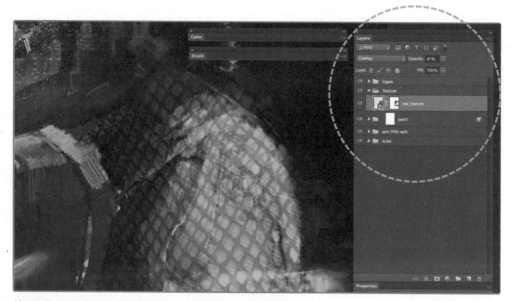

Above: The texture layer is set to Overlay, and the opacity to 40 per cent.

Above: Dragging the black slider for the Underlying Layer to the mid-point removes the texture from the shadows.

Applying Lighting to Textures

1. In this example, the texture layer has been set to **Overlay**, and the **opacity** reduced to 40 per cent so the effect is not overpowering.

2. By double-clicking the texture layer, you can open the **Layer Style** window. Using the **Blend if: Gray** setting, drag the black (shadows) slider for the Underlying Layer along the gradient bar to the mid-point.

3. The texture has now vanished from the darker values. To subtly reintroduce more texture to the darker mid-tones, hold down the **Alt** key to **split the slider**, then drag the left one back down the shadow range. Click OK when you are happy with the results.

Above: Splitting the slider allows you to bring back some texture to the darker mid-tones.

A WORLD OF PLUG-INS

CREATIVE LIGHTING PLUG-INS

Here, we look at a selection of plug-ins that enable you to add creative effects to your paintings or digital artwork, from realistic lens flares to fantasy effects.

KNOLL LIGHT FACTORY 3

Knoll Light Factory 3 may well interest you if you are creating science fiction imagery. Created by legendary effects guru John Knoll (also one of the men responsible for the original Adobe

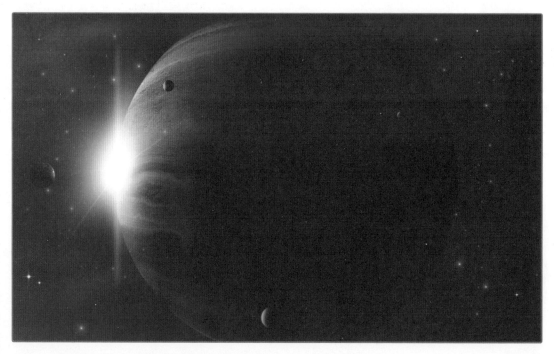

Above: Lens flare can work well in digital paintings set in space.

Above: Knoll Light Factory 3 offers many options for creating realistic and fantastical lens flare effects.

Photoshop), its main purpose is to create beautiful lens flares. For more information, head to www.redgiant.com/products/all/knoll-light-factory.

Lens Effects

With Knoll Light Factory 3, you get over 100 lens flare presets, giving you a wide range of options to add halos, ethereal glows, stars and much more. The plug-in works best when used with photorealistic imagery – which lends itself very nicely to sci-fi art (think dark skies and shiny, reflective materials). Of course, after applying the filter on a new layer, there's nothing stopping you editing it in Photoshop to refine or change the look.

Creating Special Effects in KLF3

Creating cool lens flares and lighting effects in Knoll Light Factory 3 is simple. We will take a look at how to create, and customize, an effect, but there are many more things you can do with the software – see the website on page 91 for a full trial and user guide.

see the website on page 91 for a full trial and user guide.

Hot Tip

Once you are happy, you can save the flare you have created as a preset for use on other images. Just hit the Save button below the Presets panel.

1. **Open up Photoshop** and the image you would like to add your lens flare effect to, or simply create a new document and fill it with black. The latter will enable you to get a basic idea of the effects the plug-in can generate before experimenting on your artwork.

2. Go to **Filter > Red Giant Software > Knoll Light Factory** and in the window that opens, take a look at the Presets panel. There are 104 presets, which can be used as they are or customized. And, of course, we want to do the latter.

3. Begin by choosing a preset. We've chosen **Arc Welder** – a striking blue flare with subtle trails. To the right of the Presets panel and below the main preview window, you will find the master controls for tweaking the preset.

4. Try upping the **brightness** of the flare to see the effect, and then altering the **colour** by hitting the box next to Color and choosing a new one from the picker that appears. Play around with the scale to either match your image or get the desired effect. To move the flare, you simply drag it around the canvas, the trails automatically following and updating as you do so.

5. Next, take a look at the **Elements of Light** panel on the right-hand side of the interface. Here, by unchecking the boxes, you can remove certain elements of the lens flare. In addition, when you select the element, you can adjust its individual properties.

DIGITAL FILM TOOLS' RAYS

Digital Film Tools' Rays plug-in (which is also available as a standalone application) is a great tool for adding beams (or indeed rays!) of light to your artwork, perhaps shining through a window (imagine a scene in an old church or building with the sun shining through a huge window and you get the idea). Like all of the plug-ins here, Rays tends to work better with photo-based imagery or 3D renders, but can be used effectively in concept art.

The Rays Interface

Rays is a simple plug-in to use and you can achieve great results in no time at all. On the next page we take a look at the interface:

Tools Panel Preview Window

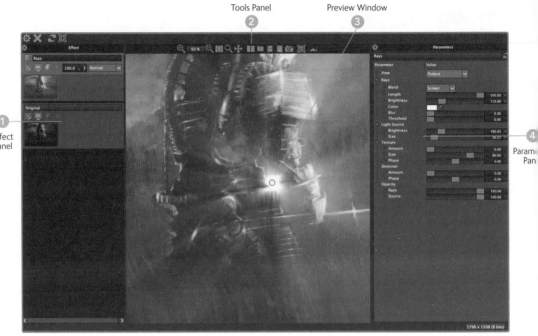

Effect
Panel

Param
Pan

Above: The Rays plug-in interface.

1. **Effect panel**: This panel enables you to quickly flick between the image with the effect applied and your original.

2. **Tools panel**: Use the tools here to quickly navigate the main preview. Handily, you can apply a side-by-side comparison – split vertically or horizontally – to check the effect of the filter.

3. **Preview window**: Here, you will see what the effect looks like when applied to your image. The dot in the centre enables you to change the point at which the light originates.

4. **Parameters panel**: The heart of the Rays plug-in, and where you can tweak every parameter from Light Source Brightness to the blending mode of the rays on your image.

AUTO FX MYSTICAL LIGHTING & AMBIANCE GEN1

If ethereal lighting is what you are looking for in your artwork, Auto FX's Mystical Lighting & Ambiance Gen1 (snappy title, we know) may be just what you are after. This is a suite of filters, enabling you to add special lighting effects to your images, either globally or within selections defined in Photoshop.

A Host of Effects

The plug-in suite contains 33 lighting and shading effects, including the ability to stream natural light beams, create realistic lightning bolts, lights through mist and add bokeh blur – the last using the Fairy Dust filter. There's also a great Light Brush, enabling you to paint light on to your canvas.

Unconventional Interface

Mystical Lighting doesn't have the most conventional interface, and it does feel somewhat dated (and it can be a little slow in its operation). However, the effects are interesting and easy enough to use once you have mastered the toolset (and can be brushed on to the canvas and then tweaked using sliders, which is a great feature). Mystical Lighting & Ambiance Gen1 costs £130/$199, and you can download a free trial from www.autofx.com.

Three of the Best Mystical Lighting Effects for Fantasy Artists

- **Fairy Dust:** This filter effect enables you to brush on a wide variety of twinkles, sparkles, snowflakes, light flares and other shapes on to your image.

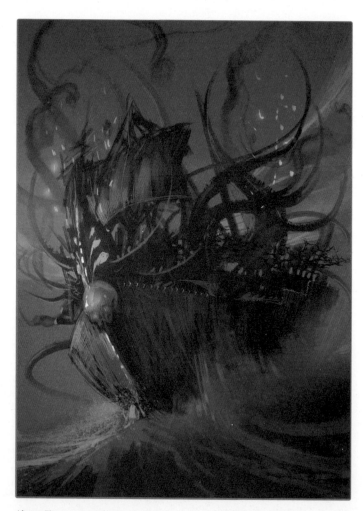

Above: There are many filters and effects that can be used in fantasy paintings.

- **Ethereal**: This effect enhances images by adding in tonal diffusion and light to soften and enrich the lighter values in your image.

- **Mist**: As the name suggests, this effect gives you the ability to brush realistic-looking mist on to your images.

Hot Tip

Experiment with combining filters – such as Ethereal and Fairy Dust in Mystical Lighting – using different layers and blend modes to enhance the effect.

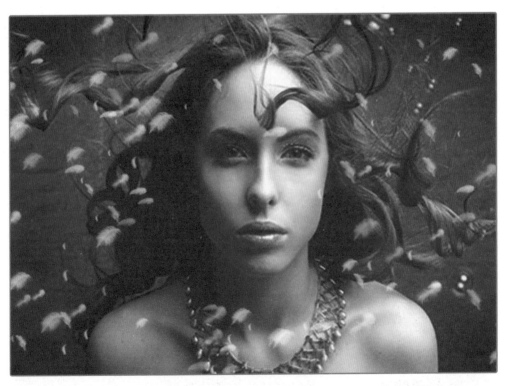

Above: Mystical Lighting from Auto FX enables you to add a range of fantastical lighting effects (Fairy Dust pictured here) to your images.

LIGHTING CORRECTION AND GENERATION

There are also lighting plug-ins that enable you to tweak the overall feel of your image and add new light sources. Here, we take a look at them and how they can be used in your artwork.

GOOGLE'S NIK COLLECTION

Google's Nik Collection of plug-ins is predominantly aimed at photographers wanting to correct and add stylish effects to their images. That said, the effects here can be of use to artists – especially if photography is a starting point of your work or you include photographic elements.

Suite of Tools

The Nik Collection contains seven filter effects in total, each with a specific use. These are Analog Efex Pro, Color Efex Pro, Silver Efex Pro, Viveza, HDR Efex Pro, Sharpener Pro and Dfine. They come as a bundle, so for £99/$155, you get them all. The collection represents pretty good value for money.

Viveza

One of the plug-in filters of most interest to artists is Viveza – a tool that enables you to selectively adjust the colour and tonality of your images. Using an intuitive slider-based interface, along with a preview you can add control points to, it is easy to add lighting effects to different parts of your images without worrying about masks.

Color Efex Pro

Color Efex Pro is the other appealing plug-in in this collection for artists, again enabling you to selectively adjust your images using control points. As you place control points on the preview image, you can adjust the opacity of any of the 55 filter effects at that particular point. You can also stack different effects for different lighting treatments.

Above: Whilst Google's Nik Collection is aimed predominantly at photographers, it is a useful tool to have in your artistic arsenal.

DIGITAL FILM TOOLS' LIGHT

Digital Film Tools' Light plug-in, when used correctly, can be a brilliant – and incredibly useful – tool for artists. The plug-in enables you to add light to a scene that would normally be tricky to paint or replicate using Photoshop's native tools – such as light shining through a window on to a subject. What is more, Light is very inexpensive at only £30/$50, and there's a free 14-day trial. Find out more at www.digitalfilmtools.com.

GOBO

Light is based on the idea of GOBOs, or Go Betweens. These are physical templates that are placed

Hot Tip

In Light, you can stack different GOBOs to create even more varied and interesting lighting effects. What is more, each effect can be individually tweaked using the Parameters panel.

in front of a light source in order to control the shape of the emitted light. This means you can add virtually any kind of light shape to your artwork, all from within a simple, easy-to-use interface.

Adding Light ... in Light!

1. In **Photoshop**, or other compatible host, go to the **Filter** menu and choose Digital Film Tools > Light v4.0. This opens up the plug-in's interface.

2. Below the main preview window, you will see a number of black and white shapes. These are your **GOBO categories**. There are all manner of shapes, from flowers and windows to stars and skies.

3. Sky, stars, clouds and moons hold some interesting effects. When you **double-click** on the categories, the shapes themselves will appear in the Presets panel at the right-hand side of the interface.

4. **Select** your shape and it will appear over the top of your image in the preview window. You can now adjust the sliders in the Parameters panel to change the brightness, colour and scale of your new lighting.

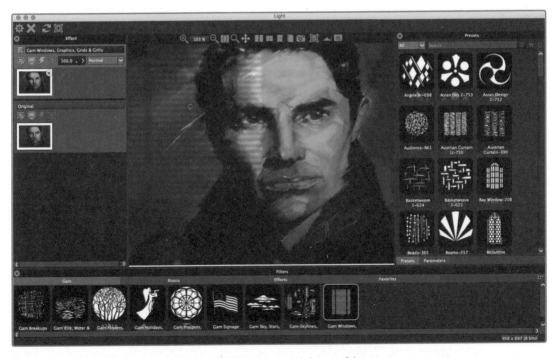

Above: Light by Digital Film Tools makes it possible to add light sources using a whole range of shapes.

THE RIGHT HARDWARE

CREATIVE HARDWARE

For any digital artwork – and especially 3D – a fast, top-spec computer is essential to avoid any kind of slowdown when you're working on your image.

Above: There are many PCs that are good enough to create digital artworks on.

SYSTEM SPECS

There are hundreds of PCs on the market that are good enough for digital painting and 3D creation, but it is a good idea to go with the best you can afford (or indeed pick the components and build it yourself if you are technically minded).

The most important things to consider – besides the Mac/PC issue, which we discuss below – are a fast processor, large, fast hard disk and ample amounts of RAM. First, we take a look in detail at what kind of hardware you need.

MAC OR PC?

The big question is whether you should use a Mac or a PC for digital artwork, and the answer lies in the kind of artwork you are doing and what you want out of your computer.

Below: The iMac is a great machine for digital artists, pairing power with great looks and a great screen.

Mac Appeal

For many years, Macs have been associated with the creative industries and they are used extensively in digital content creation. They also look brilliant and are, even in the lowest-spec model, high-performance enough for the most demanding of digital painting tasks.

iMac All-in-One

The iMac is a great all-in-one computer, offering a brilliant 21.5- or 27-inch screen in a space-saving design (and starting at only £899/$1,400). There is also a new 27-inch iMac with Retina 5K Display – capable of displaying 14.7 million pixels – but this will cost you a penny short of £2000/$3,100 at its basic configuration. If you are looking to work in 3D, however, bear in mind that some applications, such as 3ds Max, are not available for the Mac (although many applications, including the brilliant Cinema 4D, are). For more on the iMac, see www.apple.com/uk/imac.

Portable Options

You could also consider a portable Mac if you want to be able to take your primary machine wherever you go (or want a secondary laptop for painting when you are away). The main options are:

Above: A MacBook Air is very light to travel with, and has a decent amount of processing power.

○ **MacBook Air**: The most portable Mac, the MacBook Air is surprisingly powerful. The laptop is available with 11-inch or 13-inch screens with 128 GB SSDs (upgradable to 512 GB) and 1.4 GHz dual-core Intel Core i5 processor.

○ **MacBook Pro 13-inch**: The 13-inch MacBook Pro starts with a 2.5 GHz dual-core Intel Core i5 processor and a 500 GB hard drive. You can, for a little more cash, upgrade to a model with a Retina Display.

○ **MacBook Pro 15-inch**: The ultimate Mac portable, the 15-inch MacBook Pro is a real workhorse. The top-spec model comes in with a 2.5 GHz quad-core Intel Core i7 CPU, 16 GB of RAM and a 512 GB SSD. Pure power.

Above: Portable Macs are objects of beauty, with the processing power to match their looks.

PC Benefits

If you want a little more bang for your buck, a PC workstation is probably the best idea, and manufacturers such as HP and Dell offer machines that are incredibly good value for money. If you want a top-spec workstation for 3D work, there is none better than the HP Z workstation series.

These are hugely configurable, and offer super-fast Intel processors, the latest graphics cards and fast, reliable RAM and hard disks. They are pricey if you go high-spec, but you can pick one up for around £1000/$1,500 that will be suitable for both 2D painting and 3D artwork. See more at www.hp.com/workstation.

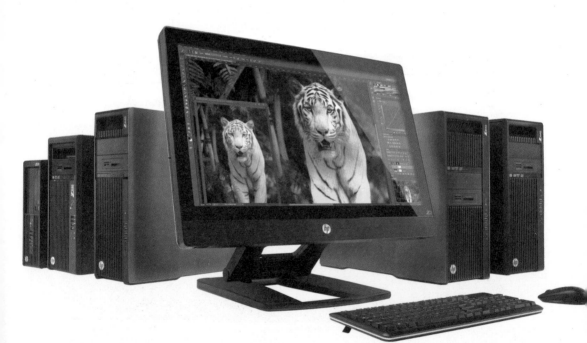

Above: HP Z workstations are just about the best you can get – hugely powerful and easy to configure for your exact needs.

RAM ISSUES

As we have touched upon, RAM is important when working on digital paintings or 3D scenes. You will need at least 4 GB of RAM if you plan on running a 2D application (such as Photoshop or Painter), and even more (up to 16 GB is recommended) if you envisage working on complex 3D scenes with multiple models, cameras and lights. Generally speaking, the more RAM, the better. This will not only enable you to work faster in your creative applications, but will also run more applications at once (so you can quickly flip between your 3D program and Photoshop, for instance).

Above: Plenty of RAM will enable your computer to deal with large programs like Photoshop with ease.

FAST AND RELIABLE HARD DRIVE

Another important consideration when kitting yourself out for digital painting or 3D modelling is a fast, reliable and high-capacity hard drive. There are generally two types of hard drive available: a standard HDD, which uses a spinning platter to read and write data; and an SSD (Solid State Drive), which uses flash memory and has no moving parts.

Above: An external hard drive can be useful for extra storage and as a way to back up your work.

Solid State Drives

An SSD is extremely fast at reading and writing data, but this comes at a cost – a 1 TB SSD can cost up to £500/$780, around ten times the price of a standard HDD at the same capacity. Again, it is best to go with the biggest hard drive you can afford; digital art files, whether 2D or 3D, can be very large and you will also want some space for reference files, photographs and so on. A 1 TB hard drive should suffice, but it is also a good idea to buy a larger external hard drive for backup purposes.

> # Hot Tip
>
> **A 3 TB USB 3.0 external hard drive only costs around £125, and it could save you from disaster. Make sure you back up your work often!**

Above: A large monitor that has a high-resolution display will be a great benefit.

THE RIGHT MONITOR

Of course, if you are going to be creating images at large sizes and that have a huge emphasis on colour, you are going to need a monitor that not only displays your colour accurately – hugely important when working on lighting effects – but that also gives you enough screen real estate to display your artwork at comfortable viewing sizes and zoom levels.

Ultra Sharp Displays

Luckily, monitors – or displays – have come down in price a lot over the last few years, and displays such as Dell's UltraSharp range offer 24-, 27- and 29-inch models at very reasonable prices. There is also a new raft of panoramic monitors, giving you a 21:9 aspect ratio and, in the Dell UltraSharp U2913WM's case, a 29-inch display with a resolution of 2560x1080.

Above: A panoramic display such as the Dell U2913WM gives artists a huge amount of screen real estate.

Dual Monitor or Panoramic Display?

Models such as the Dell U2913WM could negate the need for a dual-monitor setup – something that many creative professionals prefer. Why? Well, you can have your main canvas or scene on one monitor, and your palettes, tools and even email/web browser on the other one. This kind of setup helps you focus on your artwork – and as long as you are familiar with your application keyboard shortcuts, can really speed up your painting or modelling work.

Hot Tip

With a dual-monitor setup, you could have Photoshop on one screen and Painter on the other, making it easy to quickly switch between applications.

CHOOSING A GRAPHICS CARD

What is a graphics card? Well, essentially, it drives your monitor. But in recent times, it has come to do a lot more – thanks to developments in both hardware and software. For 2D painting work, a high-spec graphics card really isn't that important, as long as it is relatively modern and can handle the likes of Photoshop. Any graphics card in a modern Mac or PC will certainly be sufficient.

Graphics-intensive 3D

3D work is a little different and advancements in software mean it is now possible to use the GPU – Graphics Processing Unit – to assist with rendering your 3D scenes. Complex 3D scenes are graphics intensive, and the better your graphics card – and the more RAM you have on it – the smoother your scene-creation experience will be. Some graphics cards, such as NVIDIA's Quadro range, can cost thousands of pounds, but a good gaming graphics card, such as the company's GeForce GTX range, can work brilliantly for 3D work (and cost a lot less).

Above: The Quadro K6000 is an extremely powerful graphics card, suitable for high-end 3D work. Its price – at over £4000/$6260 – matches its power.

ESSENTIAL PERIPHERALS

We have looked at the essentials for setting up your Mac or PC system for digital painting or 3D creation. But what else do you need to complete your artist studio? There are many, many peripherals and devices you can buy to enhance your setup, so here we take a look at some of them.

Above: Finding the right space for you to work in is important.

GRAPHICS TABLETS AND INPUT DEVICES

A graphics tablet is an absolutely essential purchase if you are serious about digital painting or 3D modelling and sculpting. It offers you the freedom of a digital pen, enabling you to sketch and draw as you would on paper – and indeed add lighting effects more naturally by recreating traditional brush strokes. Without doubt, the best graphics tablets are made by Wacom. Its Intuos range, whilst seeming a little expensive, is the professional's choice and a worthwhile investment for any aspiring digital artist. The Bamboo range is also a good choice for those on a budget.

Controlled via Software

A control panel enables you to – through software – customize the stylus' buttons to almost any operation you can think of, and buttons on the tablet itself can be customized in a similar way. This gives you the ability to assign shortcuts to the device, meaning you can speed up your painting work.

Above: Wacam produce the industry standard graphics tablets.

Set Up Your Graphics Tablet

The Wacom control panel (which you can see, pictured right) is simple to navigate and gives you the ability to tweak every setting of your tablet and stylus.

① You **customize the buttons** on the stylus by using the drop-down menu to the right of the interface. For instance, you could specify the top button as a double-click, or the bottom as a right-click.

Multi-touch gestures Firmnes of the tip

② You can also specify the **firmness of the tip**. The firmer the tip, the harder you have to press on the tablet.

③ With the Intuos Pro, you can also set up familiar **multi-touch gestures**, such as zooming or rotating with two fingers. These gestures work with Photoshop and many digital painting applications.

The Wacom Cintiq

If you have a bigger budget, you may want to consider a Wacom Cintiq. The Cintiq is a cross between a graphics tablet and a monitor, enabling you to draw directly on to your screen. There are a few different models available, including the top-of-the-range Cintiq 24HD Touch, which has a 1920 x 1200 resolution, is multi-touch (like an iPad or tablet) and costs a whopping £2499/$3900! In addition, Wacom makes the Cintiq Companion. *See 'Tablet Computers'*, on the next page.

Above: The 3Dconnexion SpacePilot Pro may look a little strange, but it can help you control your 3D scenes with ease.

3D Input Devices

If you work in 3D, a tablet isn't essential, but when creating textures, it can come in handy. If you are serious about 3D modelling, you may want to check out the 3Dconnexion SpacePilot Pro – a rather futuristic-looking device, which enables you to easily navigate and control your 3D models, scenes, cameras and lights.

TABLET COMPUTERS

To complement your artist workstation at home or in the studio, a tablet computer of some kind is pretty much essential nowadays.

Tablet Options

There are three main options for artists, and what you choose depends on your budget and artistic preferences:

- The first is the omnipresent **iPad**. The iPad is a fantastic tool for artists, and with iOS 8, a number of active styli appearing (meaning they communicate via Bluetooth and can be customized in their functions) and a huge amount of creative apps, it is a brilliant choice.

- The second option is to go the **Android** route, with a device such as the Samsung Galaxy Tab 3. There are not as many recognized creative apps for Android, however, so bear that in mind (developers tend to create for iOS as a priority).

Above: The iPad.

- The third and fourth options are a **Microsoft Surface** tablet, which is capable of running full applications such as Photoshop and Illustrator, or a **Wacom Cintiq Companion**, which runs Windows 8.1 and comes with a Wacom pen.

Above: The Android Samsung Galaxy Tab 3.

Ultimate Portability

Whatever you choose, you will be able to work on the move, perhaps capturing a certain tone or lighting effect when out and about, and then apply it to your artwork when you return home or to the studio.

Hot Tip

If you are after the ultimate blend of power and portability, an iPad Mini with Retina Display may be just the tablet for painting on the move.

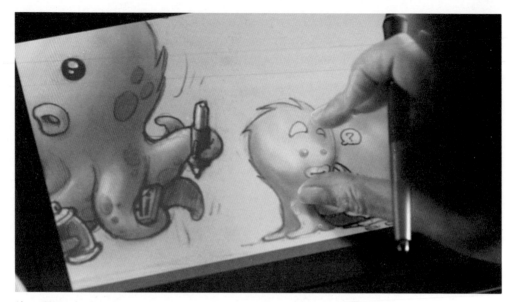

Above: The Wacom Cintiq Companion is a tablet capable of running Windows 8.1 and is a brilliant tablet for digital artists, thanks to the inclusion of a Wacom pen.

THE RIGHT CAMERA

Like a tablet or iPad, you won't find an artist nowadays without a decent camera to hand. You don't, however, need a brilliant, top-of-the-range camera, as it is likely all you will be using it for is to capture scenes, lighting, colour and texture when out and about. Even the low-end 18-megapixel Canon EOS 1200D is perfectly good, and at less than £300/$470, it is a bargain.

Stylish Portability

If you are after something a bit more portable – and perhaps stylish – check out a Compact System Camera by the likes of Olympus, Canon or Nikon. The Olympus Pen range is particularly stylish, as is the lovely, and retro, OM-D series. Of course, if you have a smartphone, its camera is likely good enough to capture enough detail for reference work.

Four Top Digital Cameras for Artists

- **Nikon 1**: Bringing the portability of a pocket camera with interchangeable lenses and stunning looks, the Nikon 1 J series – and in particular, the Nikon 1 J4 – is a superb camera for digital artists.

- **Olympus OM-D**: The OM-D E-M1 is a great-looking retro camera based on the Micro Four Thirds standard. It offers a huge range of manual controls and is a compact size that fits well in the hand and bag. Definitely one to consider.

Hot Tip

Always carry an extra SD card when out taking photos for reference. You don't want to have to delete photos when you are out and about.

Right: The Nikon 1 is one of several cameras ideally suited to the digital artist.

- **Fujifilm X-M1:** Sporting (as is the fashion, it seems) a retro, leather body, a 16-megapixel sensor and a 3-inch tilting display (plus loads of manual controls), the X-M1 is certainly a stylish camera that is capable of producing stunning images.

- **Nikon Df:** With the same full-frame, 16.2-megapixel sensor as Nikon's flagship D4, the Df is capable of fantastic, highly detailed images with excellent low-light performance. What is more, it looks the part, with its beautiful retro design.

PRINTING YOUR WORK

In the digital age, we sometimes forget about a quality printer, but as an artist, having hard copies of your work is extremely rewarding. And if you make the investment and purchase a printer capable of high-quality reproductions, you could even set up your own online

shop, or sell through services such as Society6 (www.society6.com) and Etsy (www.etsy.com).

Whilst it may seem expensive at an RRP of £570/$890, the A3+ Epson Stylus Photo R3000 is a good choice for artists – thanks to such features as its front-loading fine-art-paper feed and comprehensive paper handling.

SETTING UP YOUR ART STUDIO

You now have an idea of what hardware to kit your studio out with. Of course, there are many more peripherals and gadgets you can buy to improve your studio space, including furniture, lamps and of course prints by your favourite artists. Making your studio space your own and being comfortable working there is the most important thing.

Right: The Epson Stylus Photo R3000 is good value for money and is capable of producing high-quality art prints.

USEFUL WEBSITES AND FURTHER READING

WEBSITES

www.creativebloq.com
A creative portal from the makers of *Computer Arts* and *ImagineFX* magazine, with tutorials, news and creative goodies to download.

www.digitalartistdaily.com
An online magazine dedicated to digital art, with image galleries, tutorials, news and features.

www.digitalartsonline.co.uk
News, reviews, inspiration and advice by creative professionals, for creative professionals.

www.digitaltutors.com
Art-focused Photoshop, 3D and creative software video tutorials for beginners and pros alike.

http://tv.adobe.com
Free resource of hundreds of tutorials – all on Adobe products, of course.

http://tutsplus.com
Fantastic resource of tutorials for illustration, photography and other creative endeavours.

FURTHER READING

Birn, Jeremy, *Digital Lighting and Rendering*, New Riders, 3rd edition, 2013

Brooker, Darren, *Essential CG Lighting Techniques with 3ds Max*, Focal Press; 2nd edition, 2012 (kindle edition)

Caplin, Steve, *Art and Design in Photoshop: How to simulate just about anything from great works of art to urban graffiti*, Focal Press, 2008

Cardoso, James, *Crafting 3D Photorealism: Lighting Workflows in 3DS Max, Mental Ray and V-Ray*, 3DTotal Publishing, 2013

Gurney, James, *Color and Light: A Guide for the Realist Painter*, Andrews McMeel Publishing, 2010

Huggins, Barry, *Creative Photoshop® Lighting Techniques*, ILEX, 2004

ImagineFX Magazine, Future Publishing, available at newsagents worldwide.
www.myfavouritemagazines.co.uk

Iraci, Bernardo, *Blender Cycles: Lighting and Rendering Cookbook*, CreateSpace Independent Publishing Platform, 2014

Tuttle, Susan, *Digital Expressions: Creating Digital Art with Adobe Photoshop Elements*, North Light Books, 2010

Yot, Richard, *Light for Visual Artists: Understanding & Using Light in Art & Design*, Laurence King, 2011

INDEX